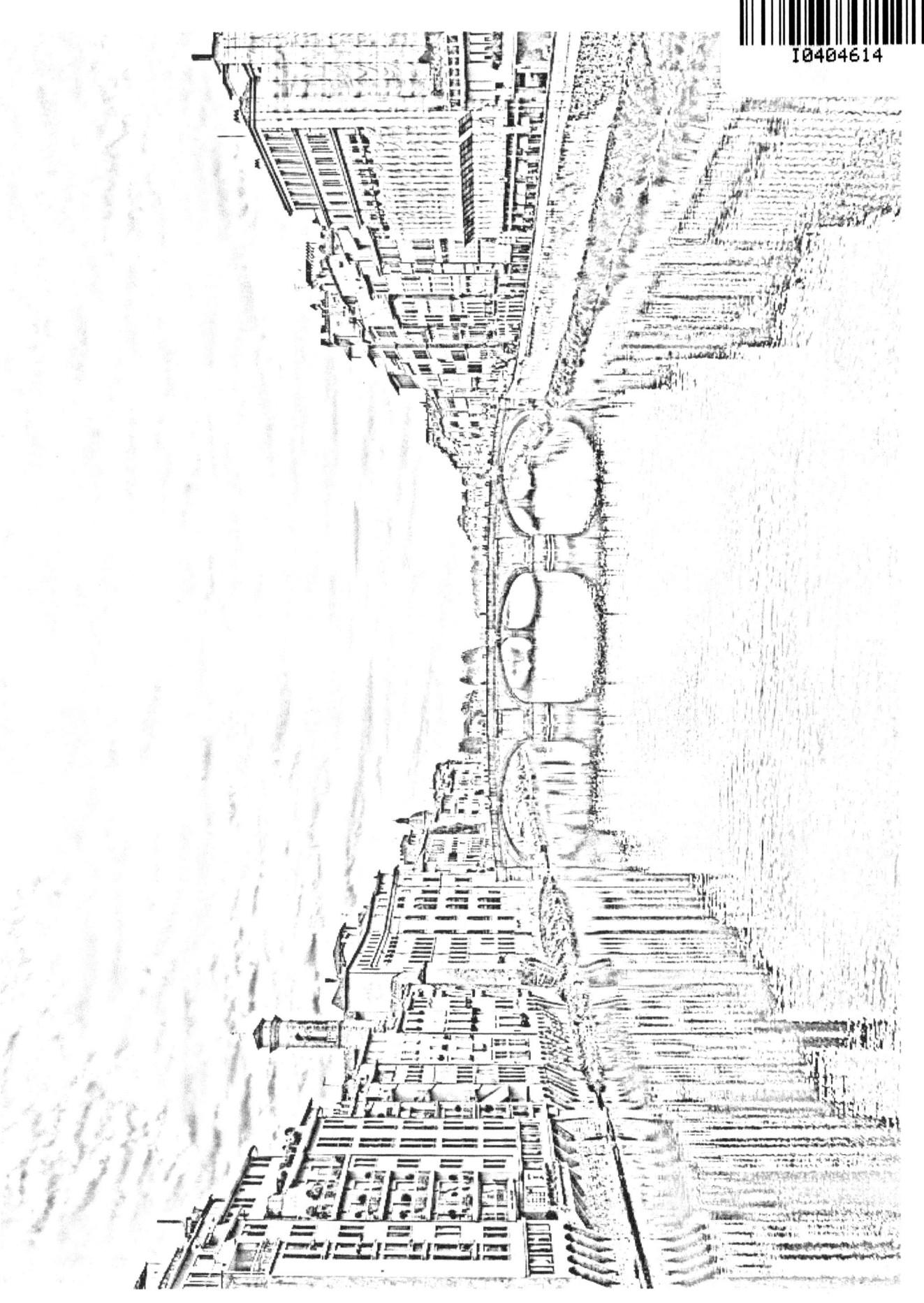

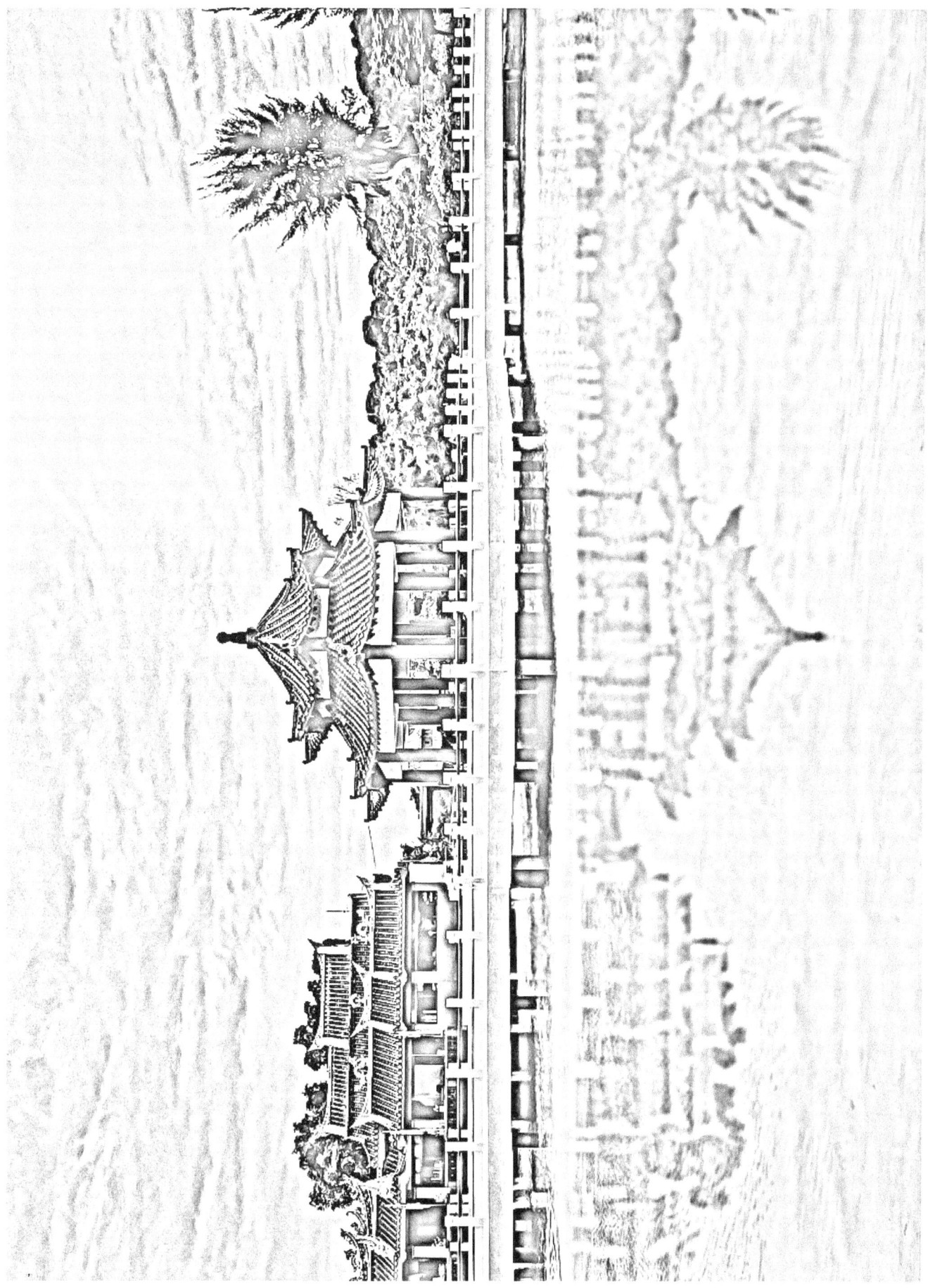

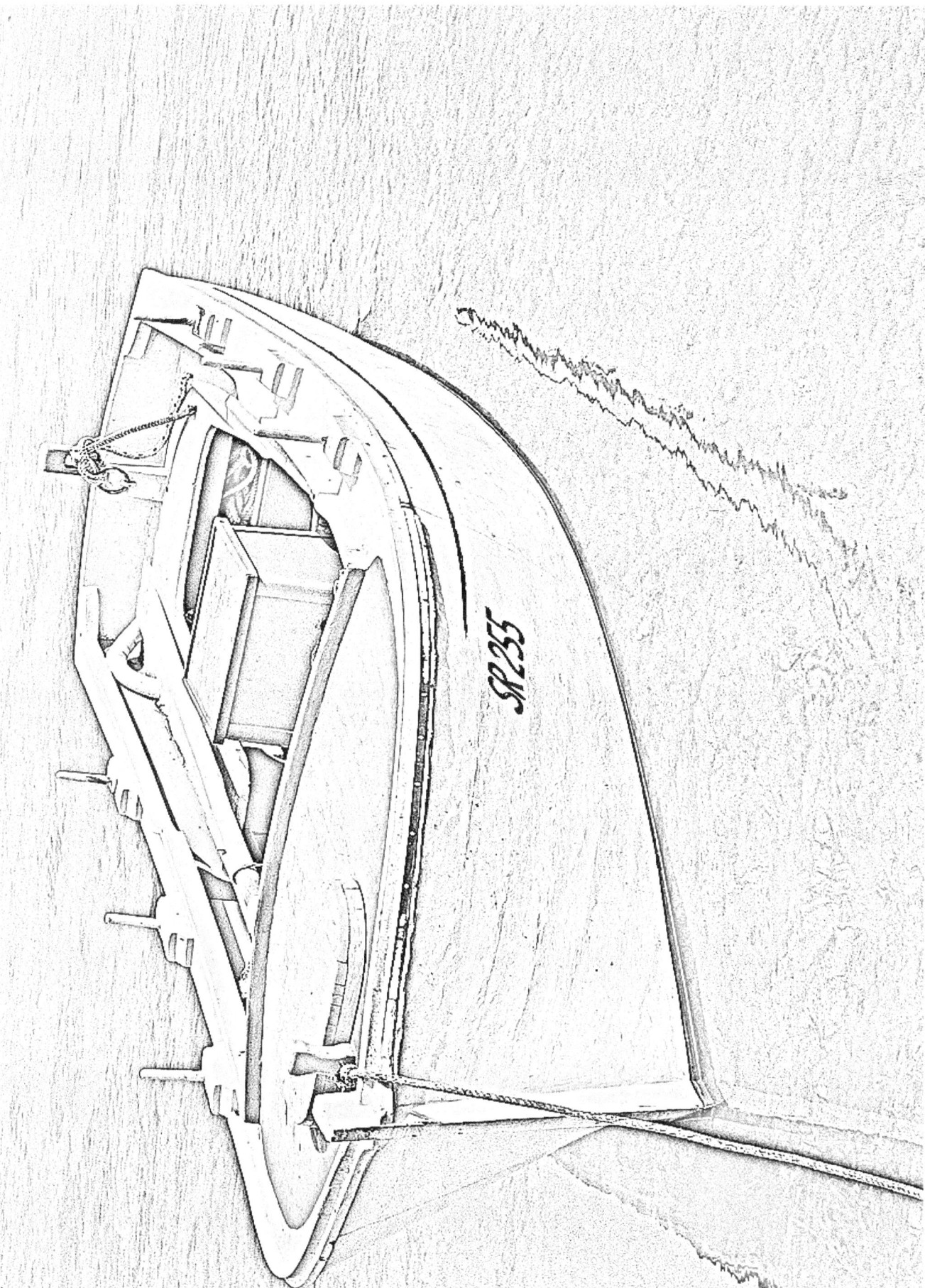

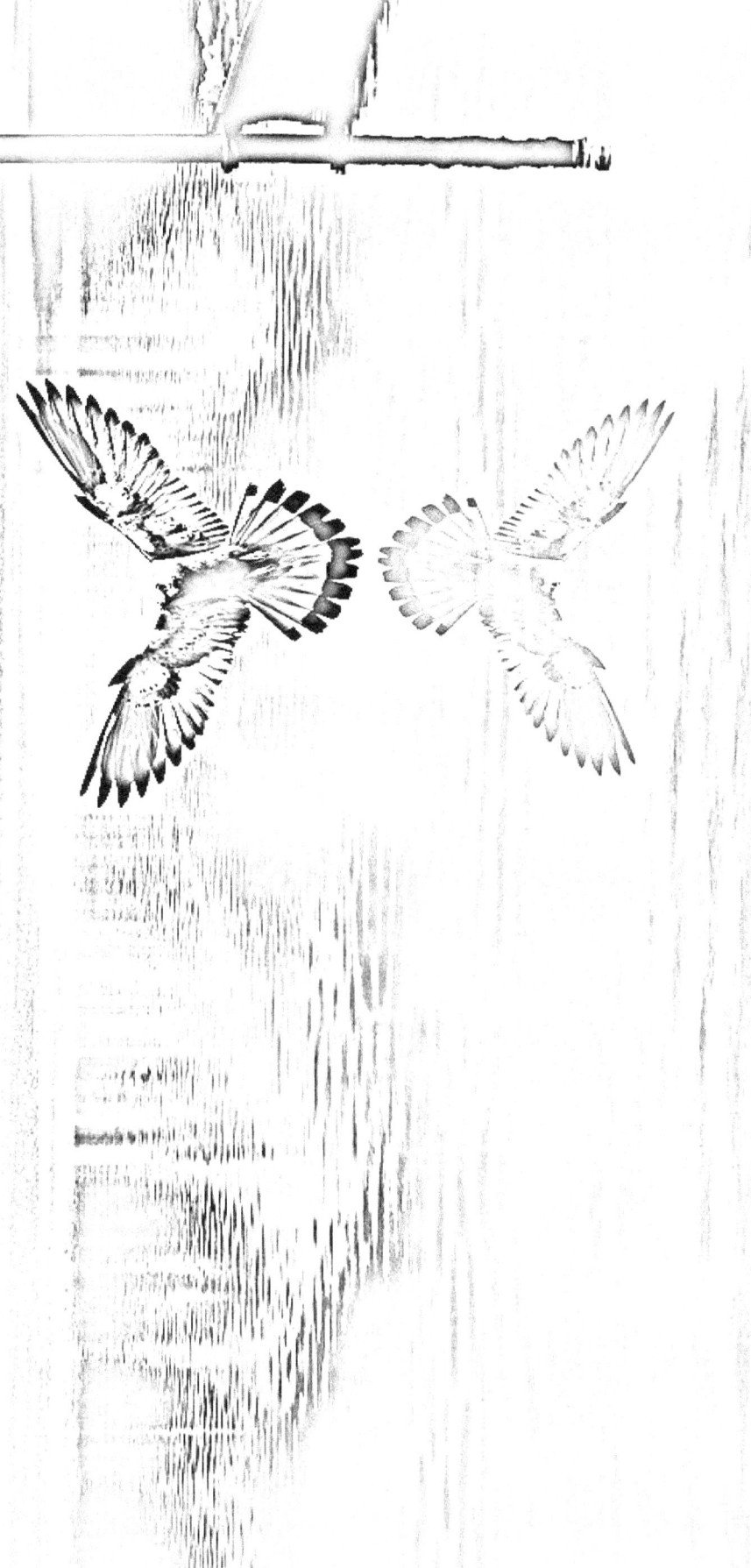

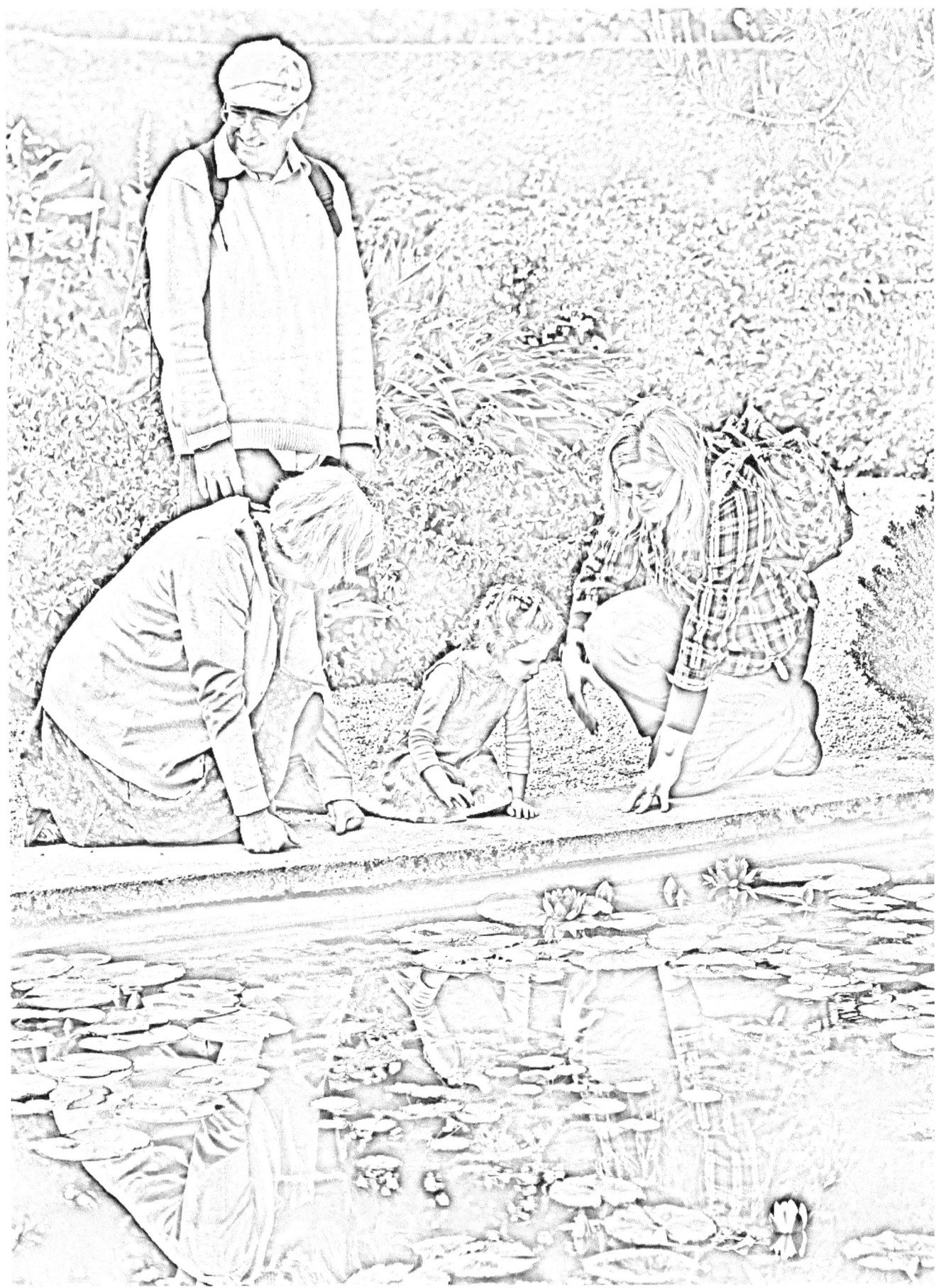

Thank You!
We hope you enjoyed our book.

Watch for more color books by ARN Arts LLC.
Visit us at http://arnarts.wixsite.com/books

www.ingramcontent.com/pod-product-compliance
Lightning Source LLC
Chambersburg PA
CBHW080631190526
45169CB00009B/3351